David Prudhomme
CRUISING THROUGH THE LOUVRE

ComicsLit

LOUVRE
éditions

ISBN 978-1-56163-990-8
Library of Congress Control Number: 2015955747
© Futuropolis/Musée du Louvre éditions 2012
© NBM 2016 for the English translation
Translation by Joe Johnson
Lettering by Ortho
1st printing February 2016 in China

Comicslit is an imprint
and trademark of

NANTIER · BEALL · MINOUSTCHINE
Publishing inc.
new york

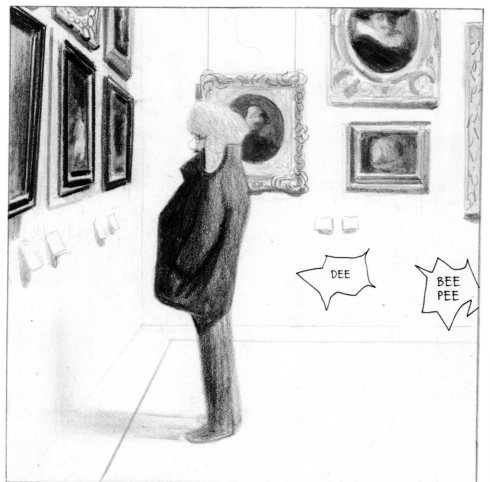
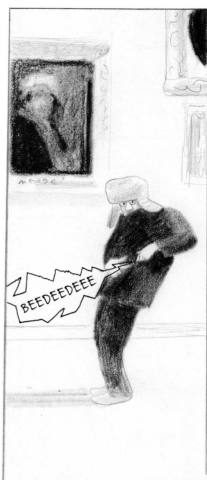

YES. WITH JEANNE. MEANDERING ABOUT.

HUH? AM I ADVANCING WITH THE BOOK?

A LITTLE. IT'S LIKE I'M WALKING INSIDE A GIANT COMIC BOOK.

5

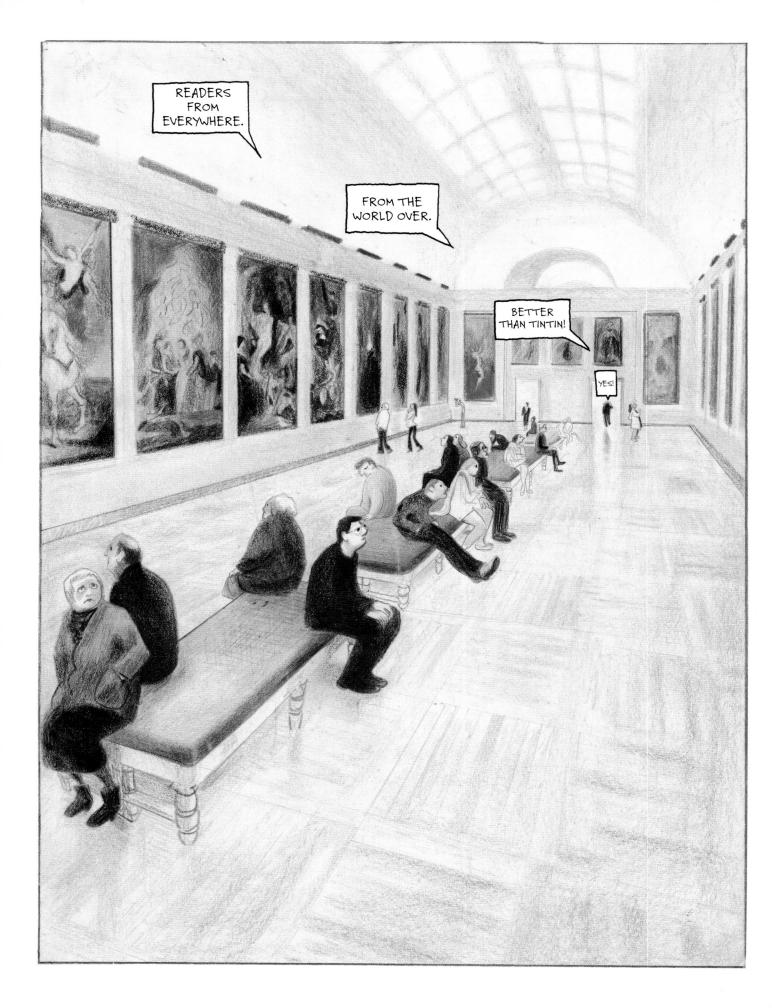

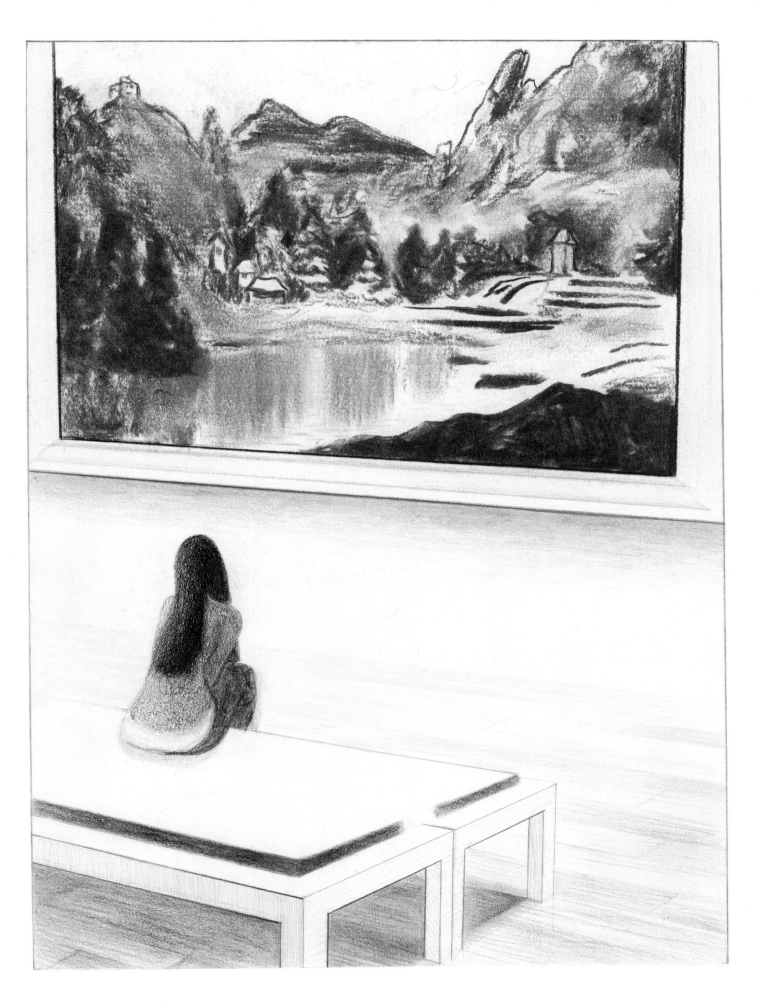

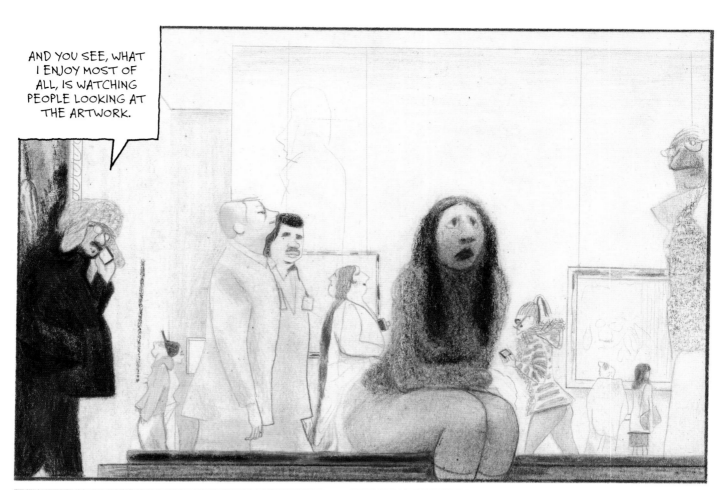

AND YOU SEE, WHAT I ENJOY MOST OF ALL, IS WATCHING PEOPLE LOOKING AT THE ARTWORK.

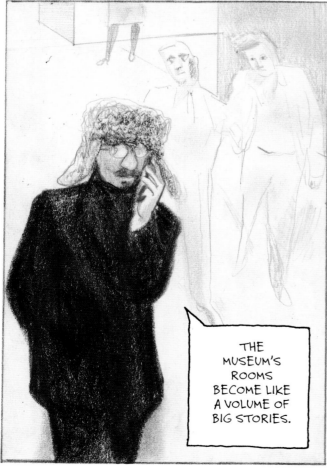

THE MUSEUM'S ROOMS BECOME LIKE A VOLUME OF BIG STORIES.

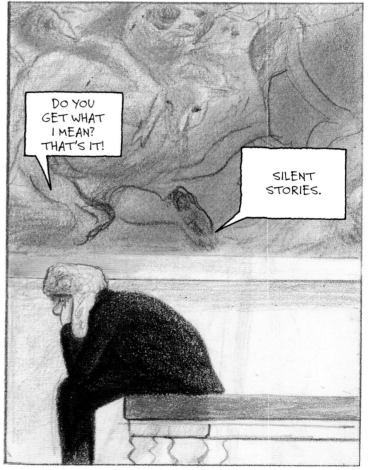

DO YOU GET WHAT I MEAN? THAT'S IT!

SILENT STORIES.

WELL NOW? WHERE'S JEANNE? YOU HAVEN'T SEEN HER, REMBRANDT?

BEE

AH! THAT MUST BE HER!

PEE

DEE DEE DEE PEE

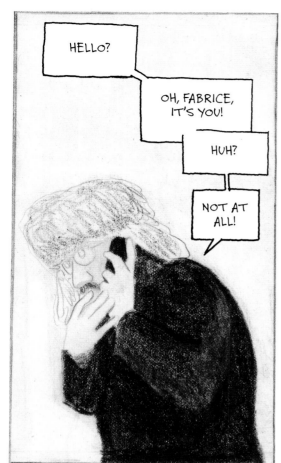

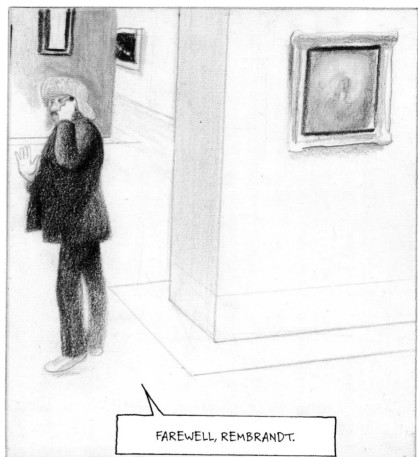

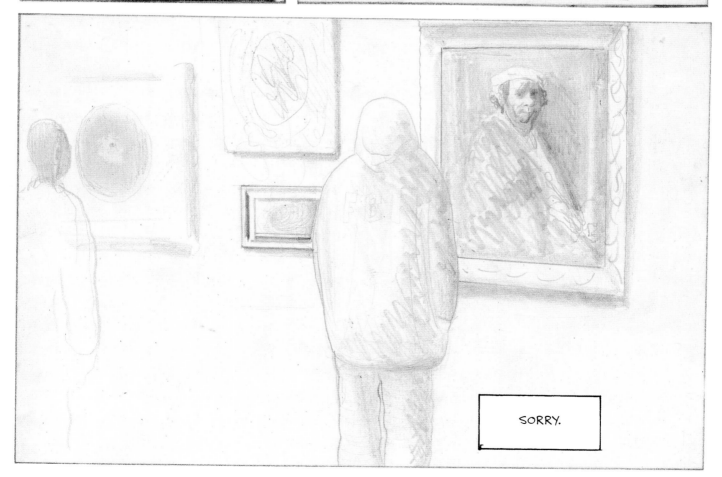

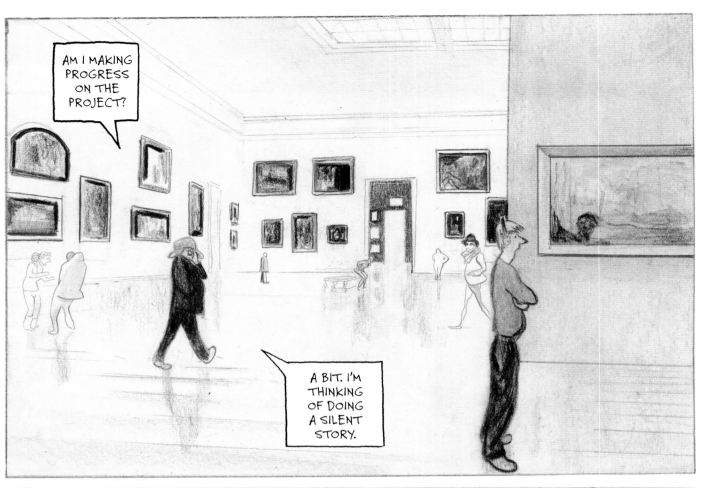

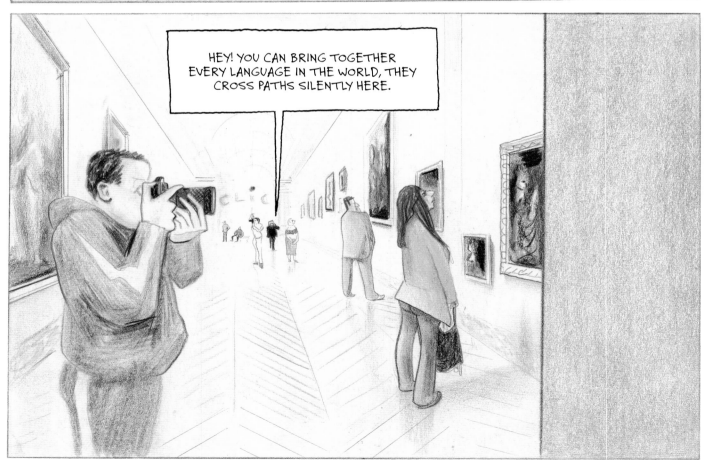

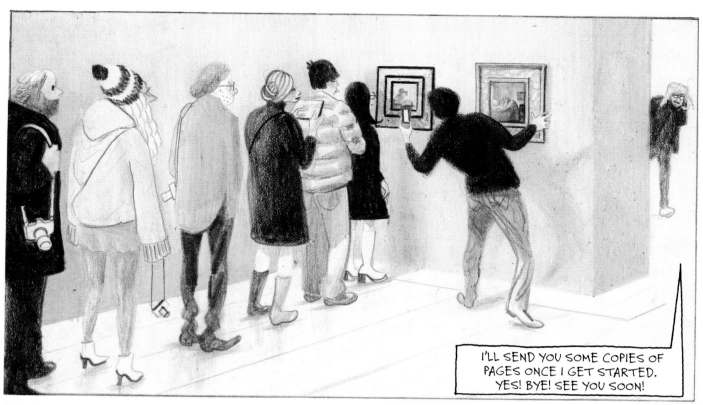

I'LL SEND YOU SOME COPIES OF PAGES ONCE I GET STARTED. YES! BYE! SEE YOU SOON!

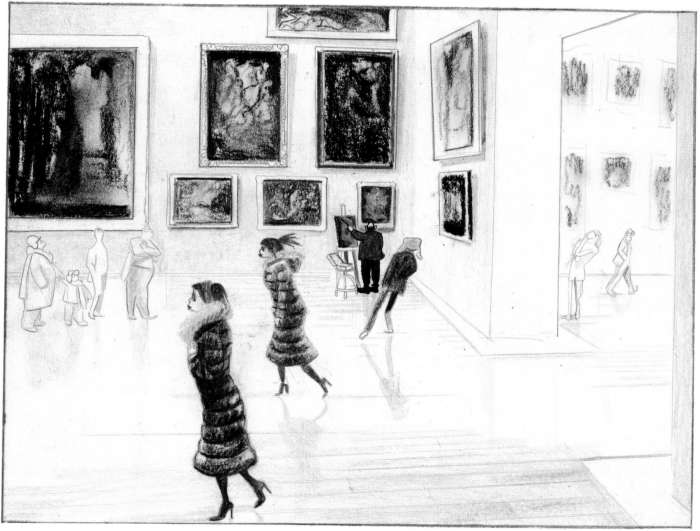

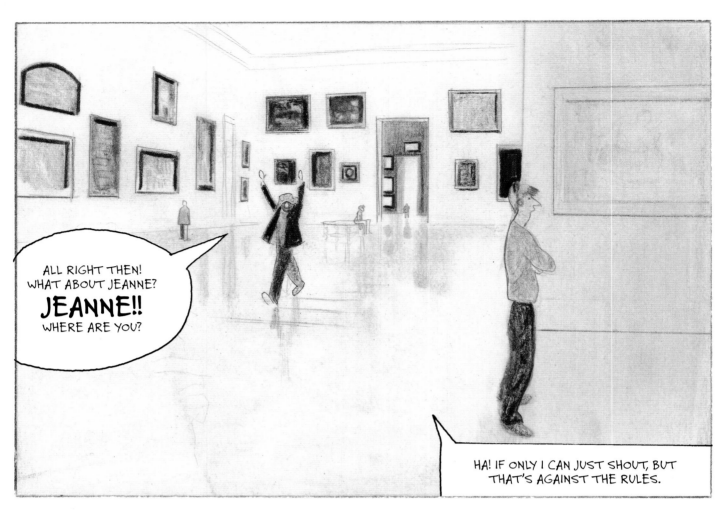

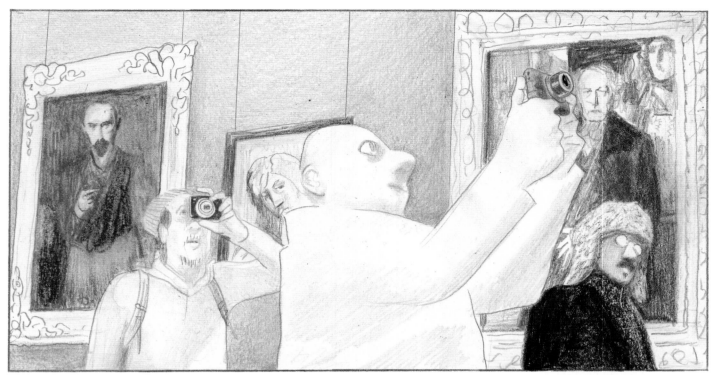

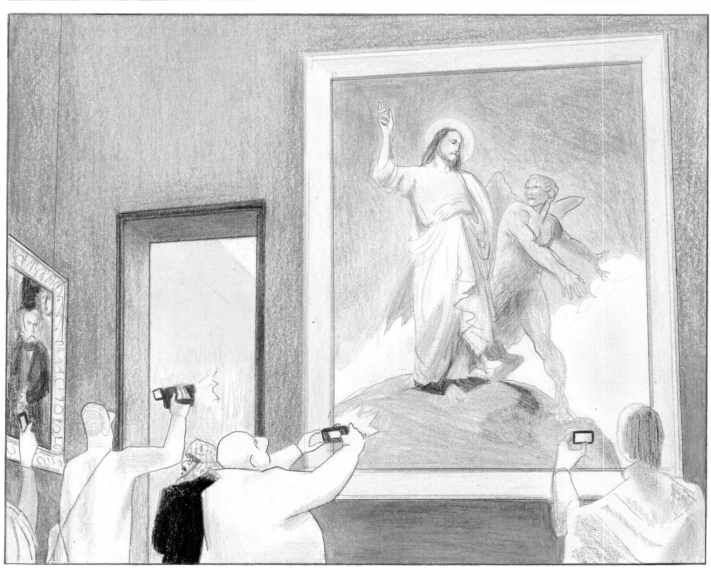

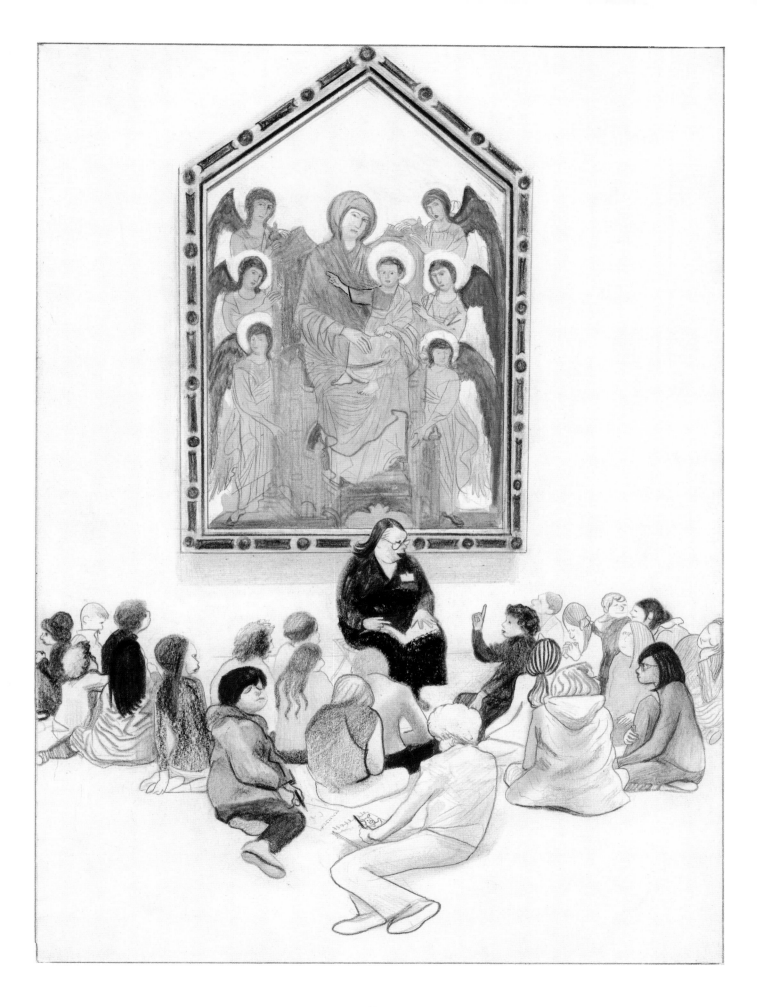

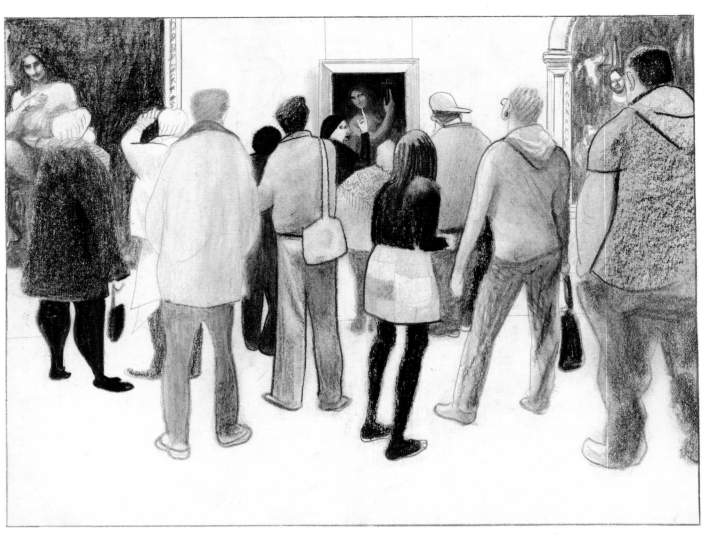

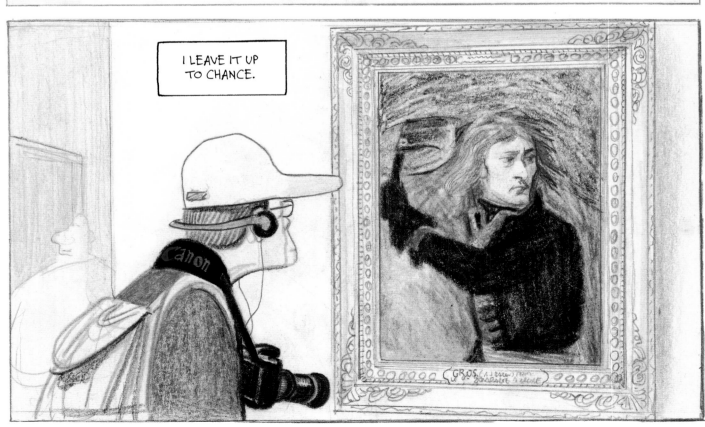

I LEAVE IT UP TO CHANCE.

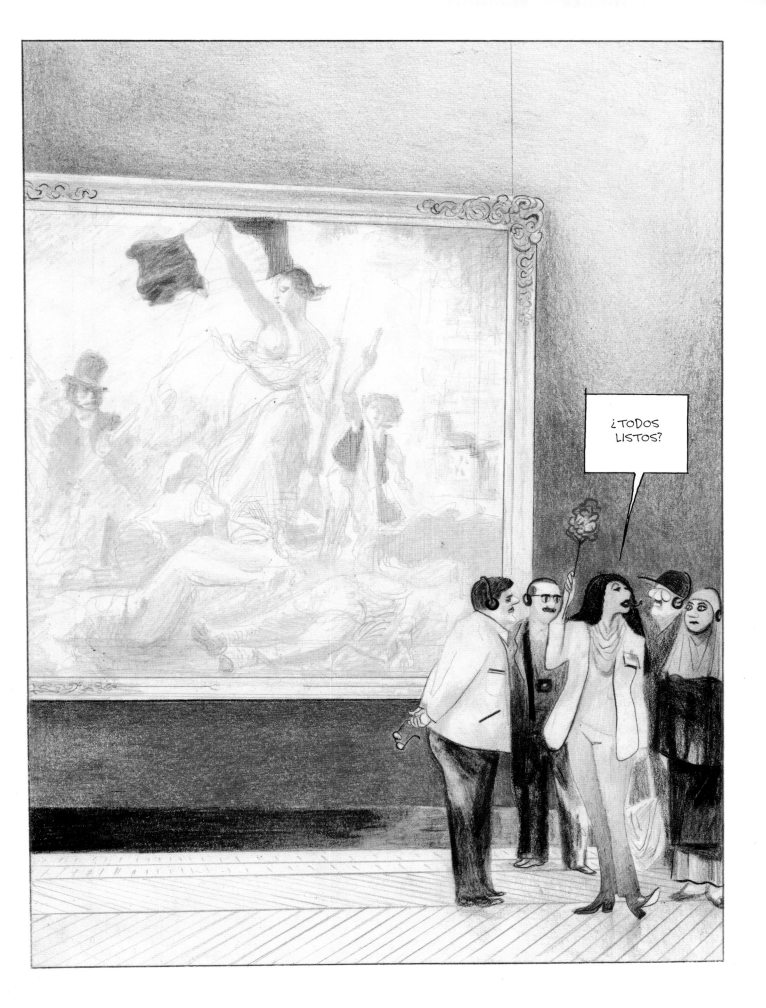

EVERYONE HERE IS DOING PRETTY MUCH LIKE ME.

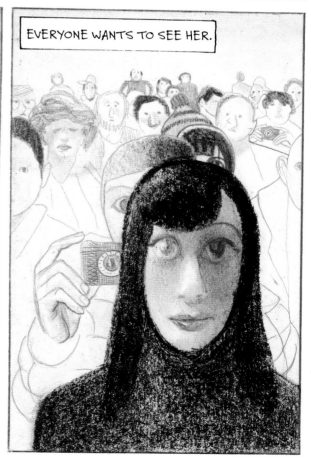

EVERYONE WANTS TO SEE HER.

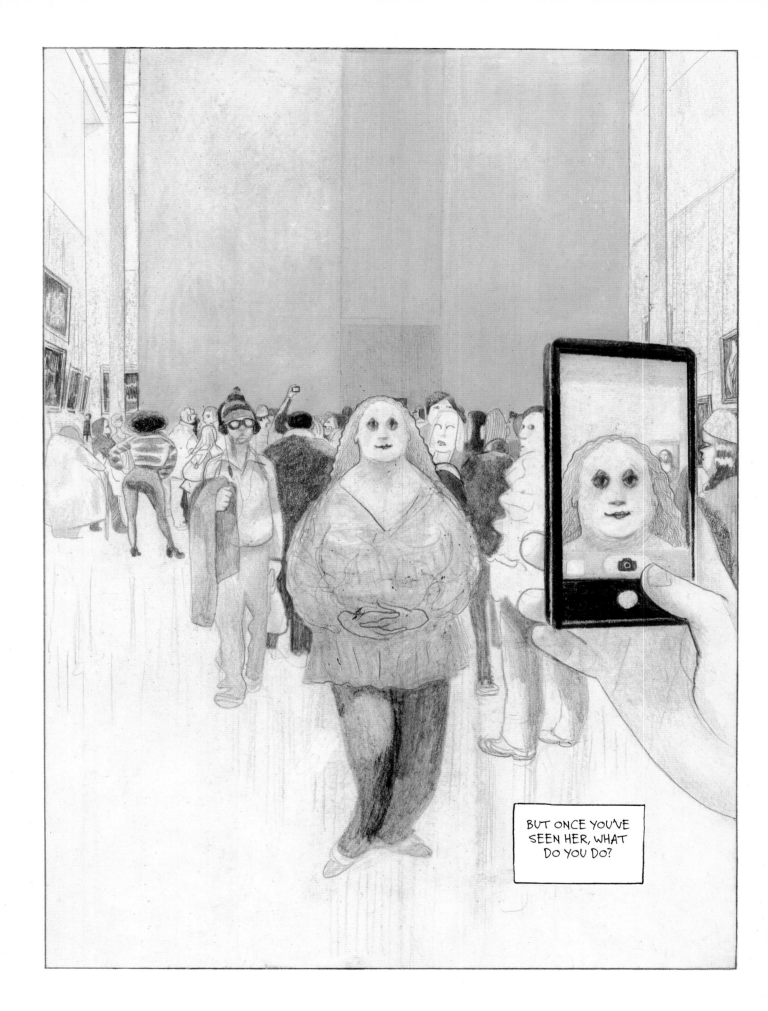

BUT ONCE YOU'VE SEEN HER, WHAT DO YOU DO?

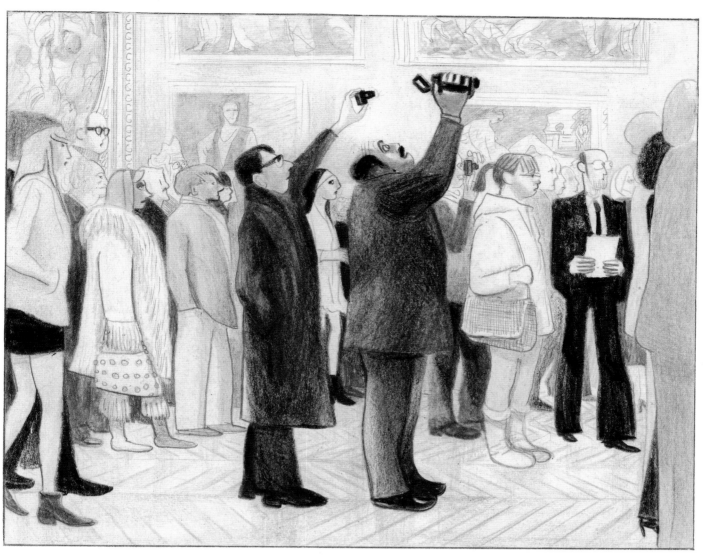

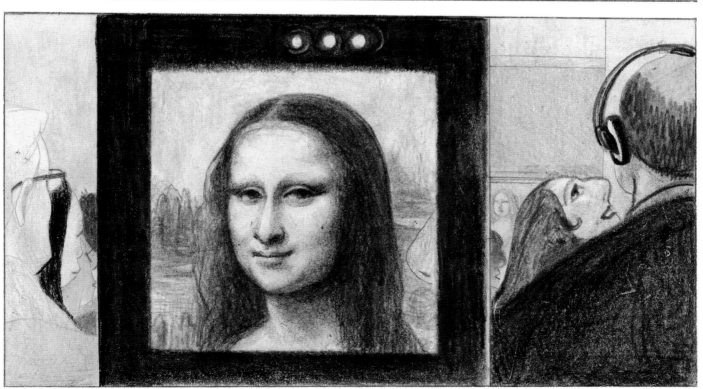

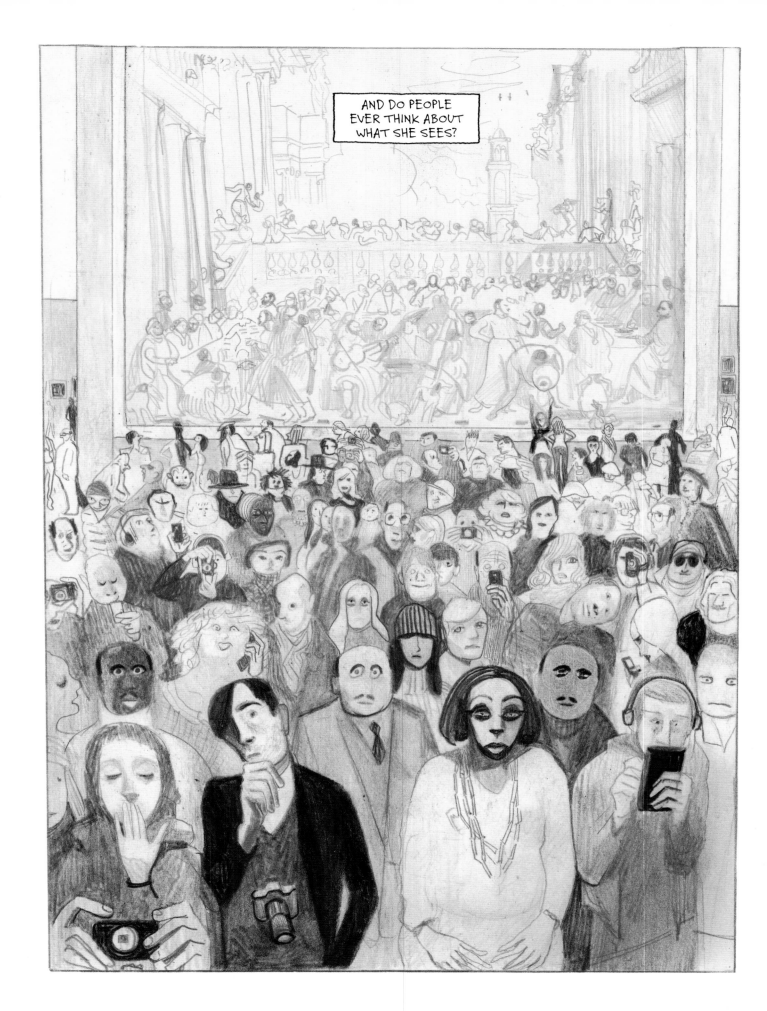

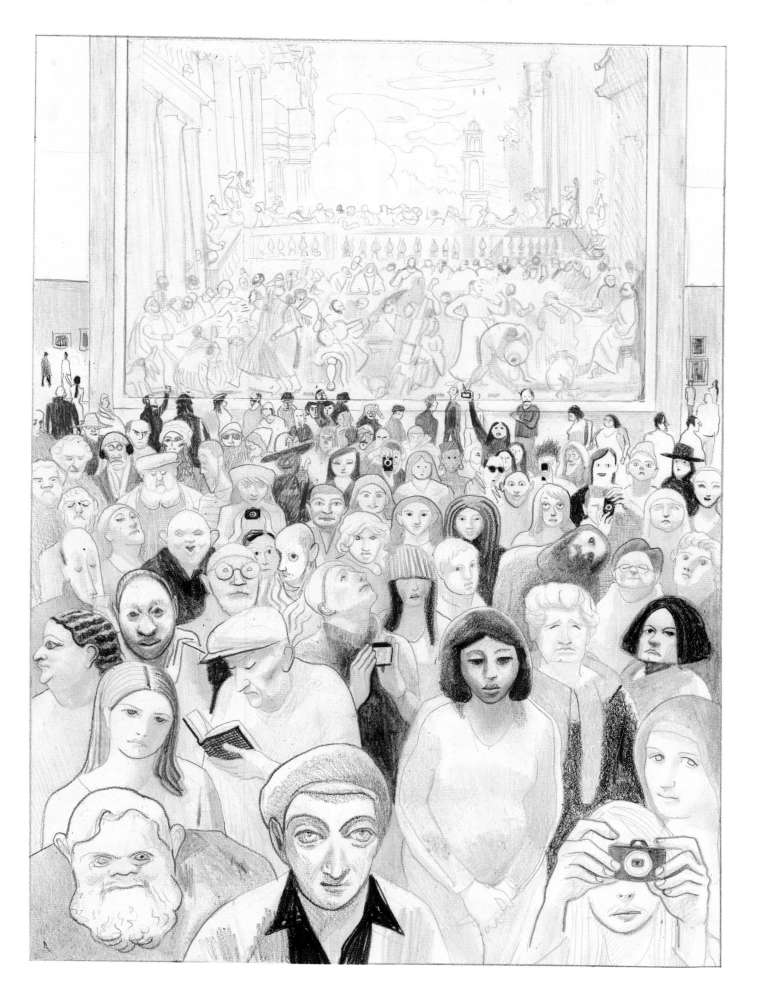

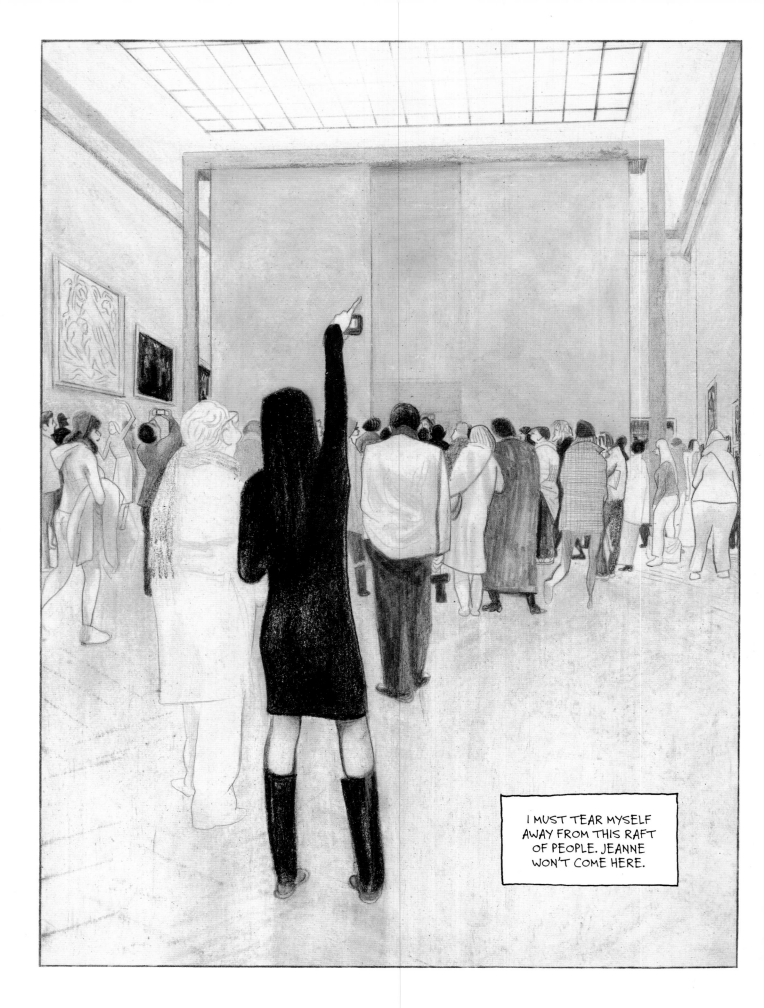

I MUST TEAR MYSELF
AWAY FROM THIS RAFT
OF PEOPLE. JEANNE
WON'T COME HERE.

HELLO!

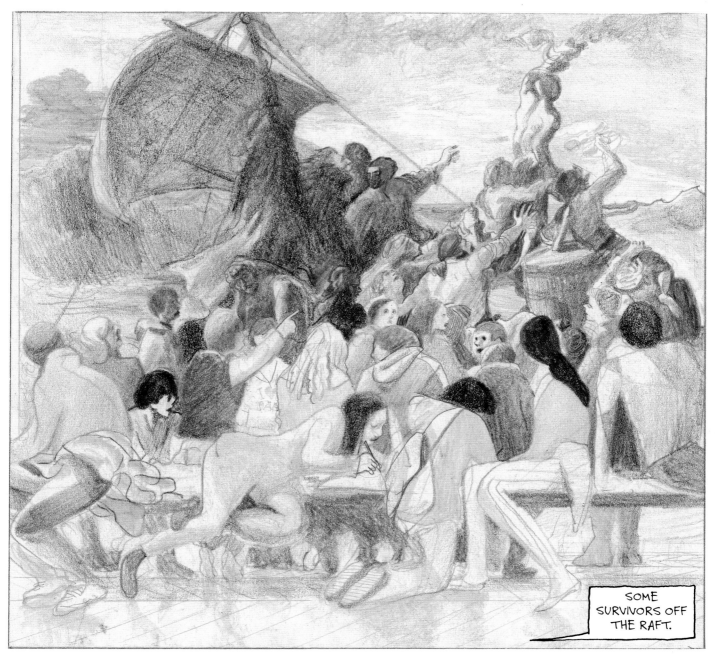

SOME SURVIVORS OFF THE RAFT.

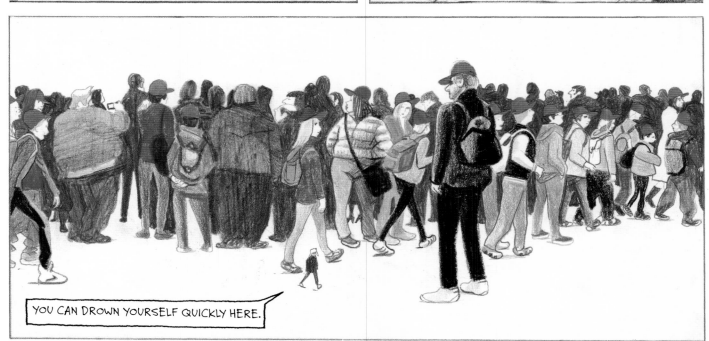

YOU CAN DROWN YOURSELF QUICKLY HERE.

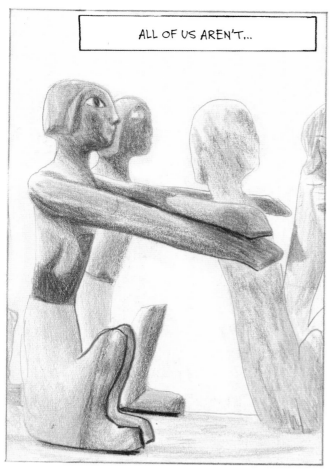

ALL OF US AREN'T...

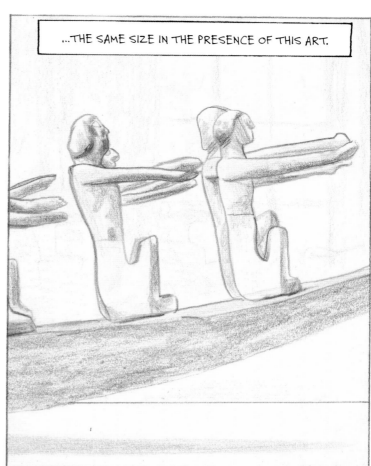

...THE SAME SIZE IN THE PRESENCE OF THIS ART.

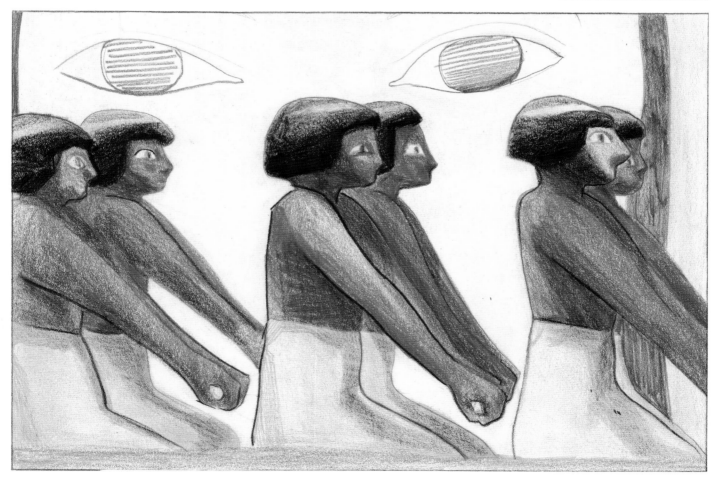

33

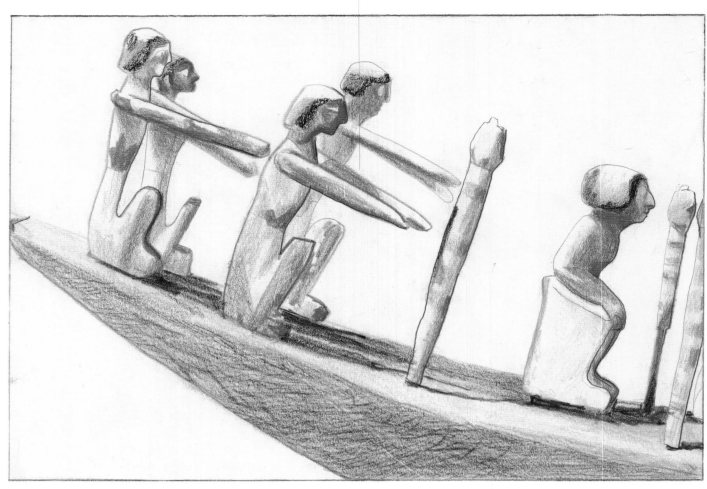

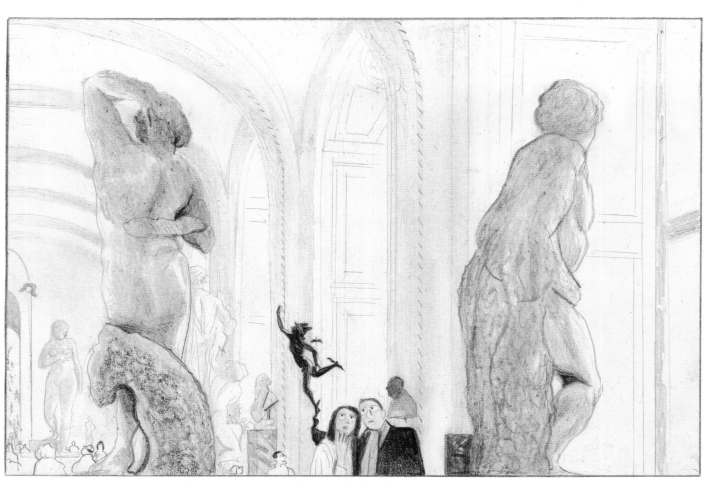

GOTTA STOP EYEING THE COUPLES.

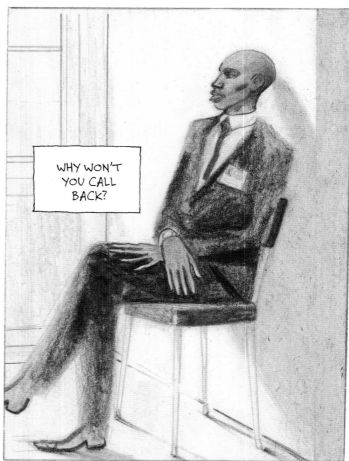

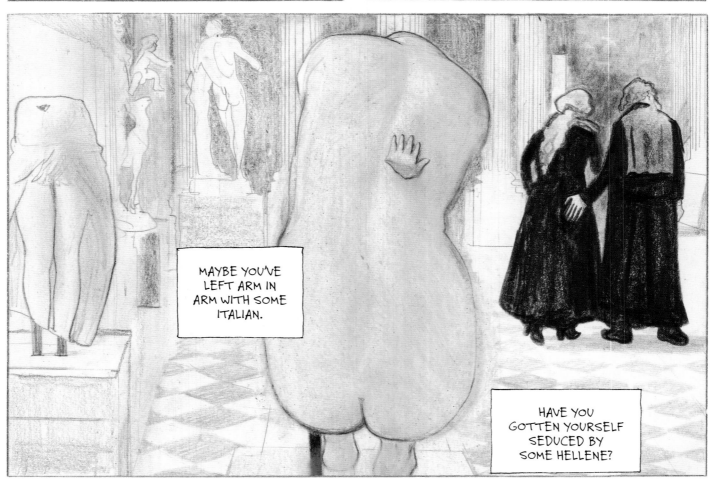

OR AN EGYPTIAN?

42

43

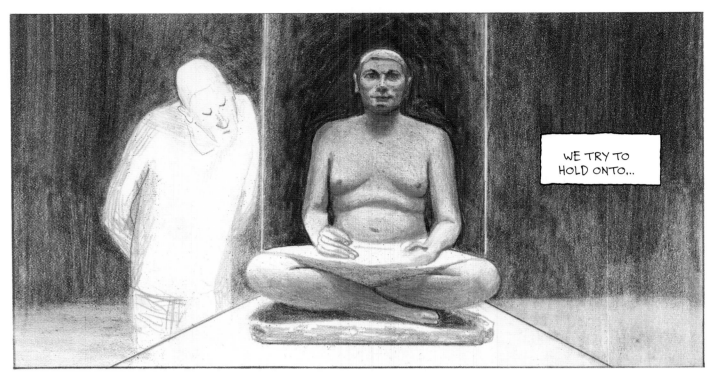

WE TRY TO
HOLD ONTO...

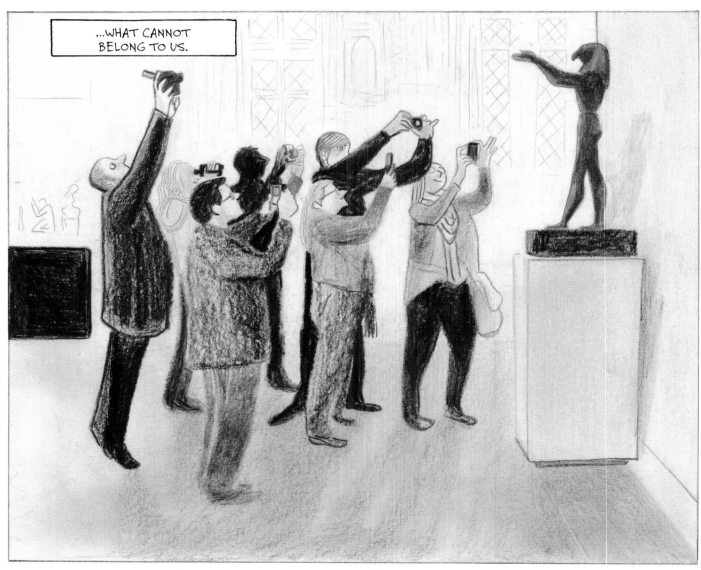

...WHAT CANNOT
BELONG TO US.

44

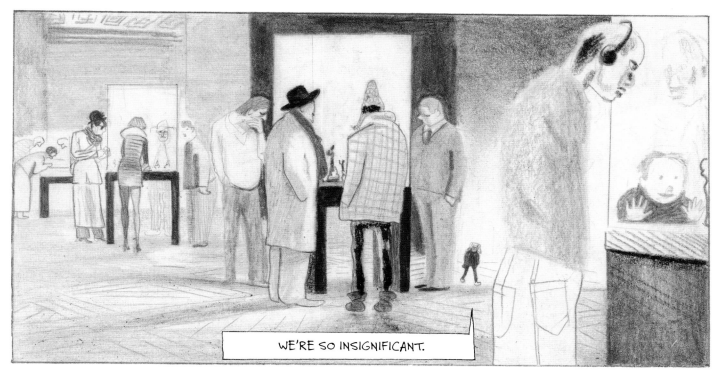

WE'RE SO INSIGNIFICANT.

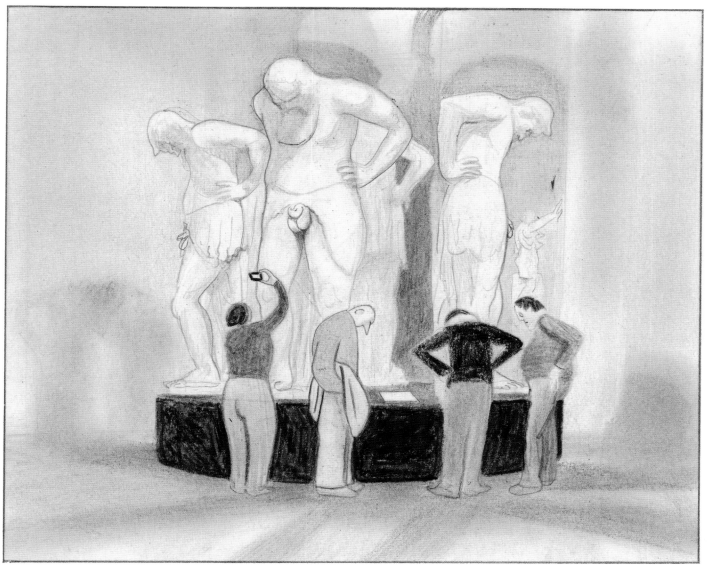

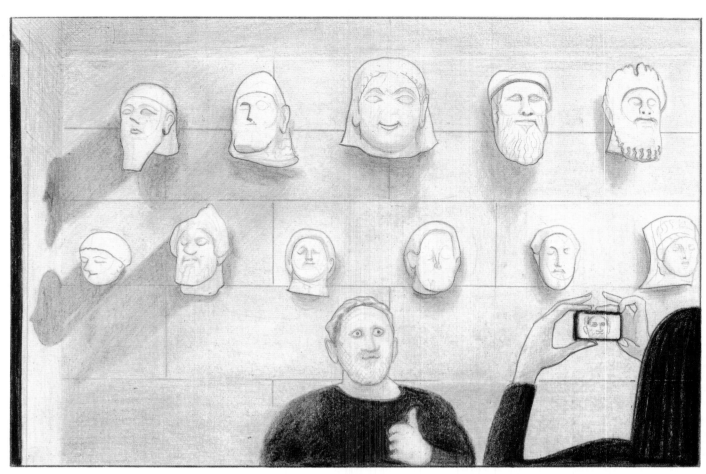

50

53

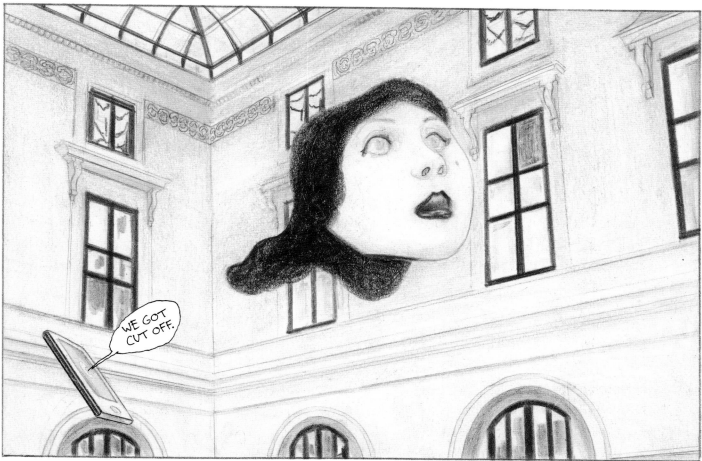

55

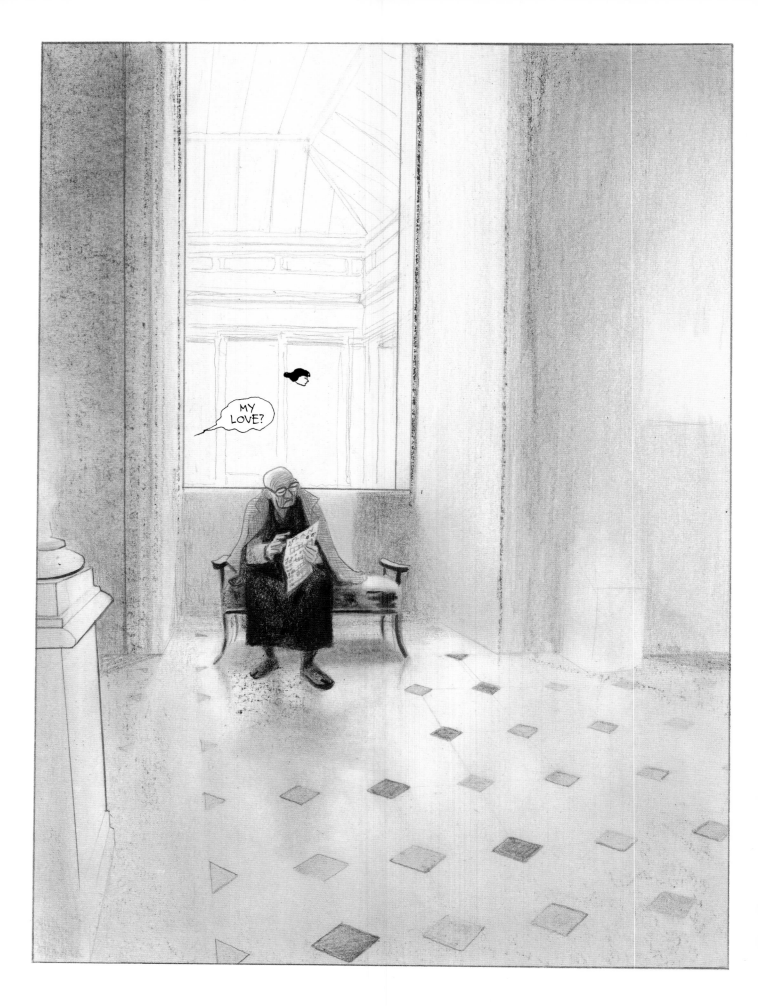

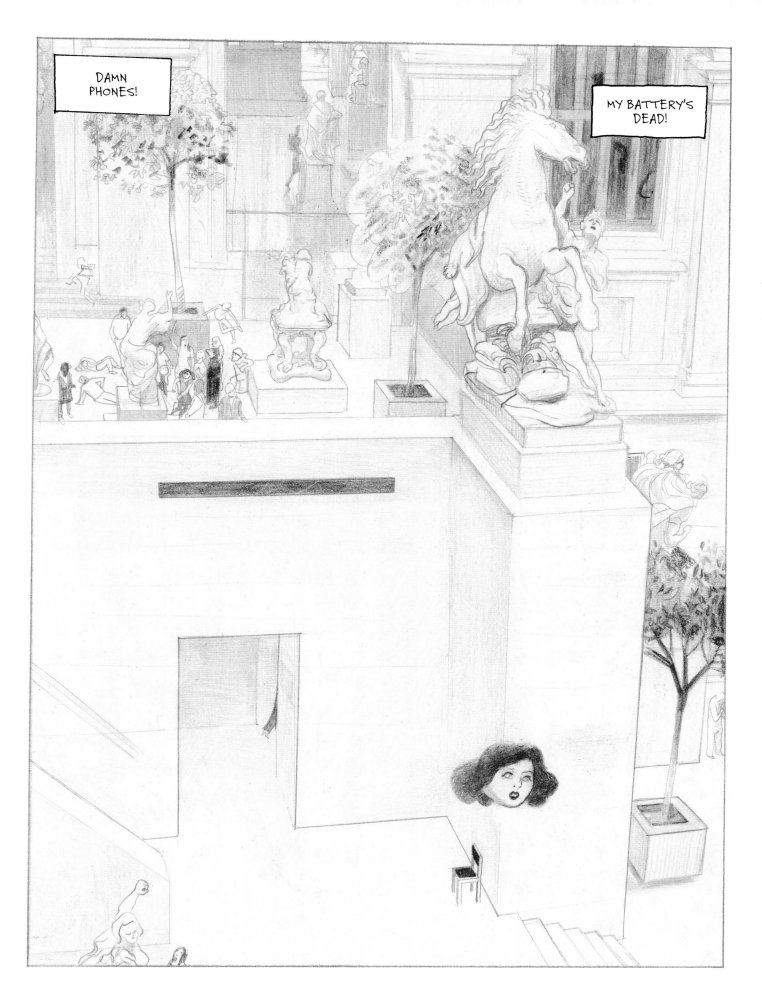

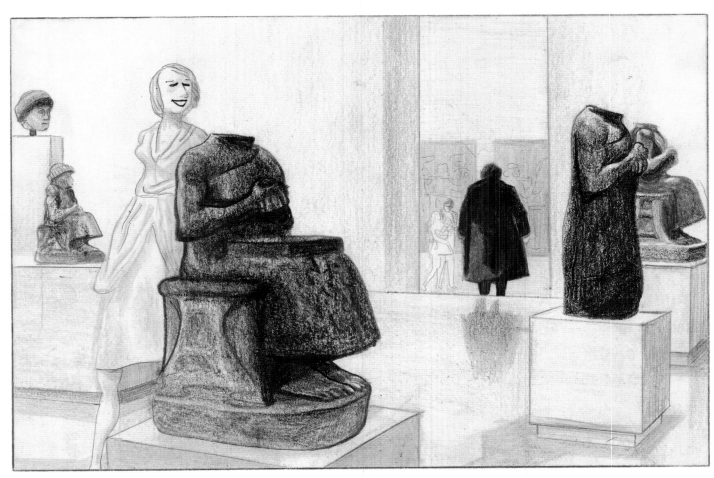

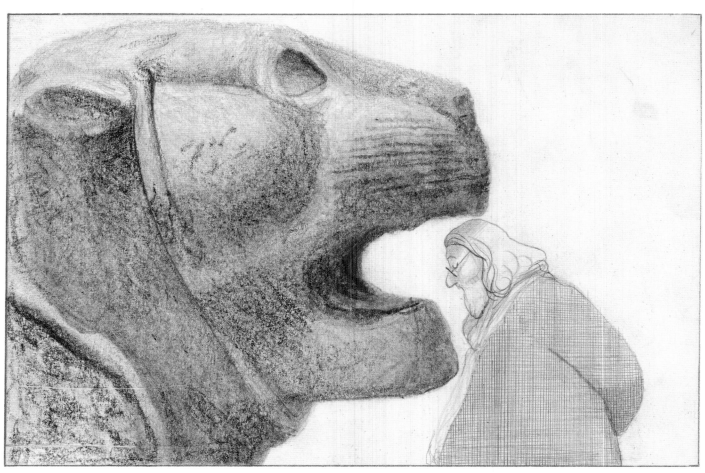

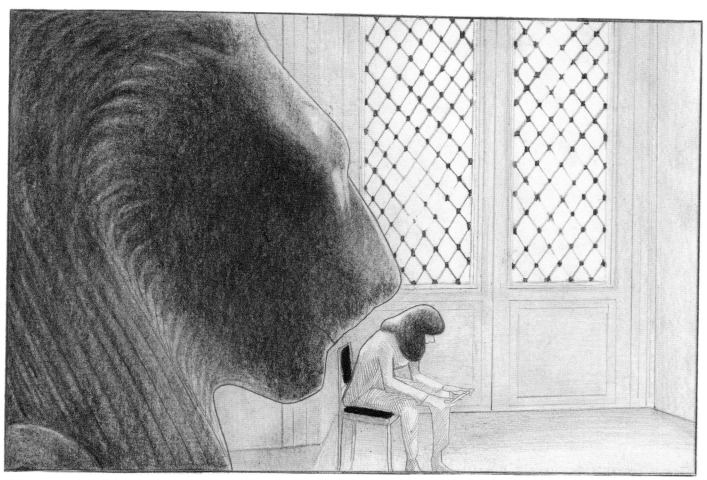

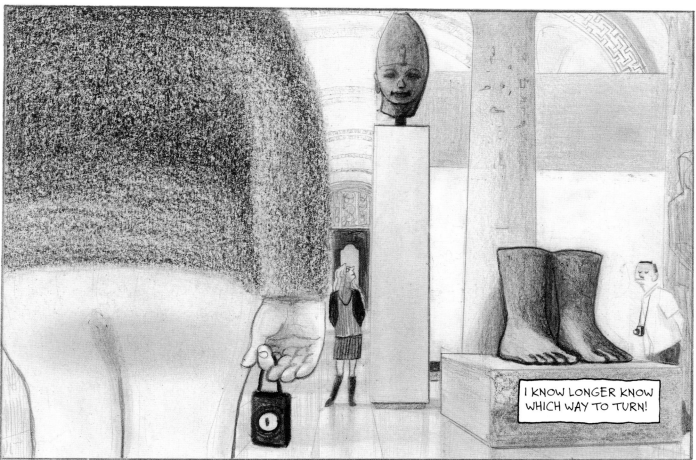

I KNOW LONGER KNOW WHICH WAY TO TURN!

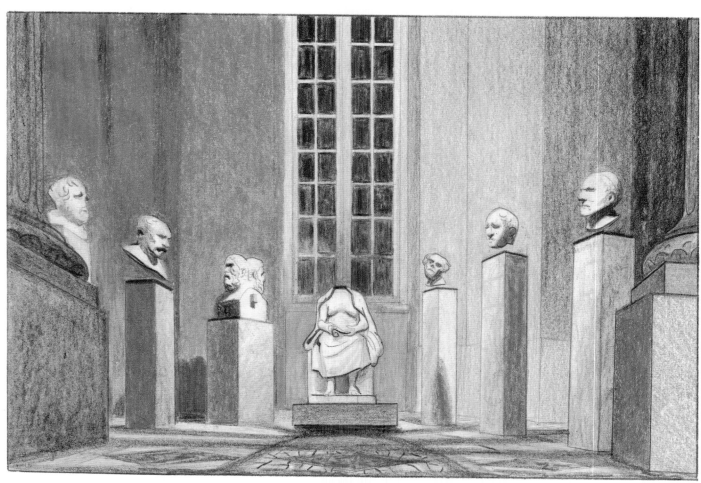

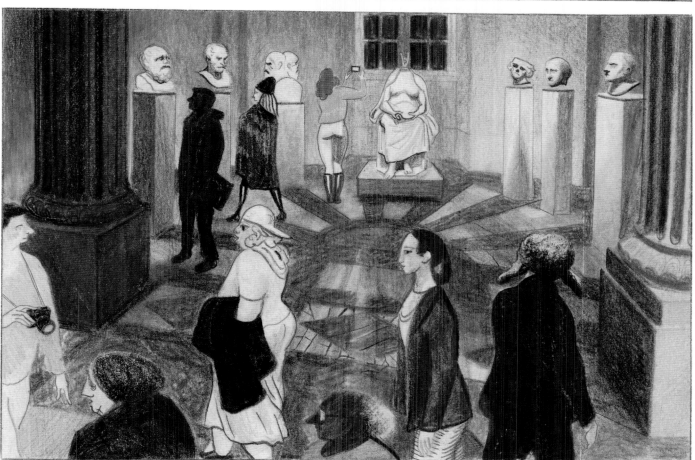

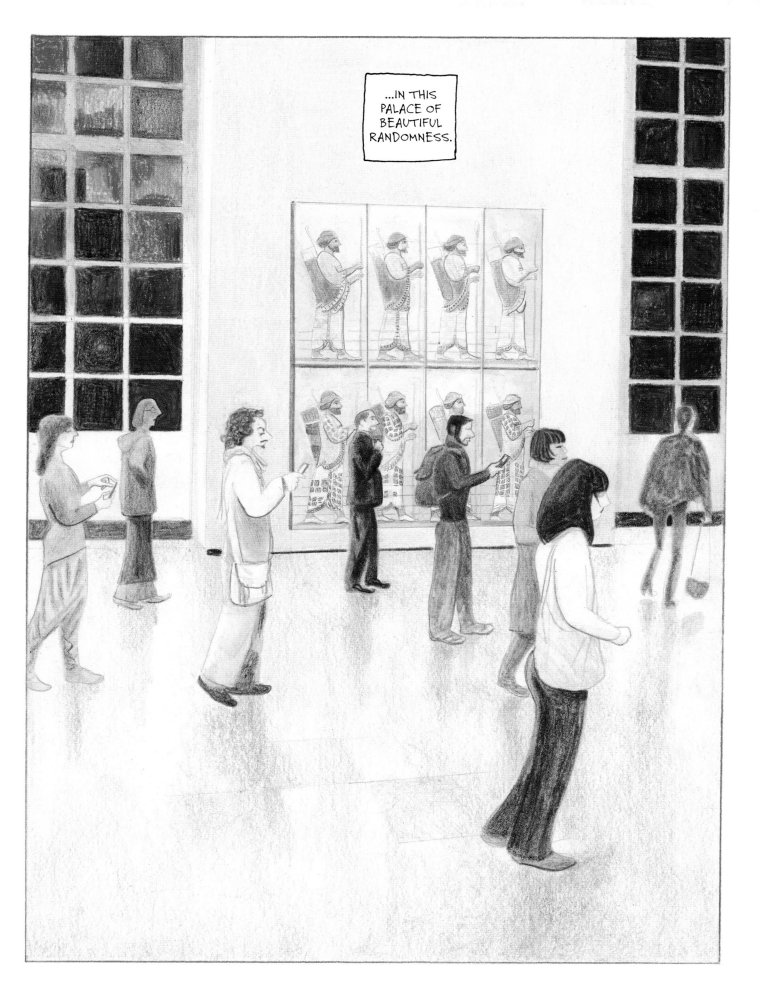

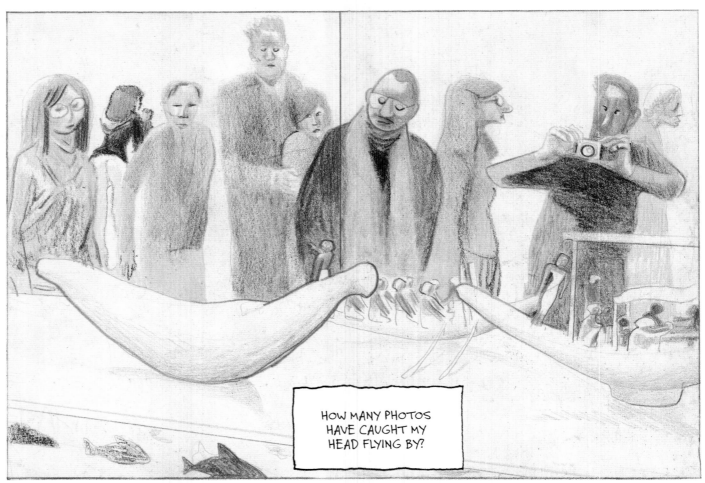

HOW MANY PHOTOS HAVE CAUGHT MY HEAD FLYING BY?

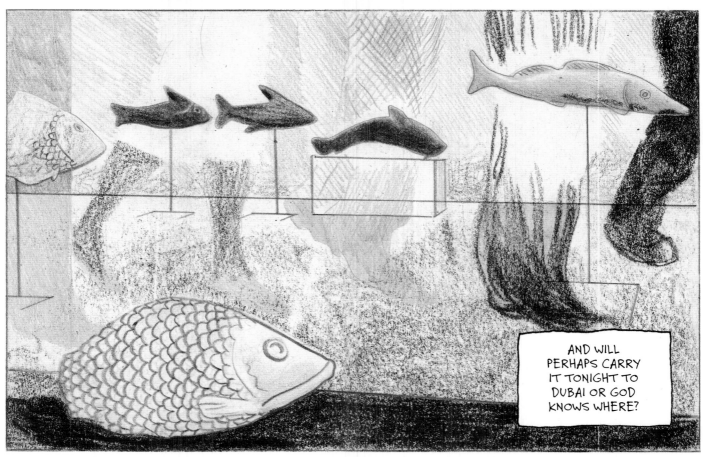

AND WILL PERHAPS CARRY IT TONIGHT TO DUBAI OR GOD KNOWS WHERE?

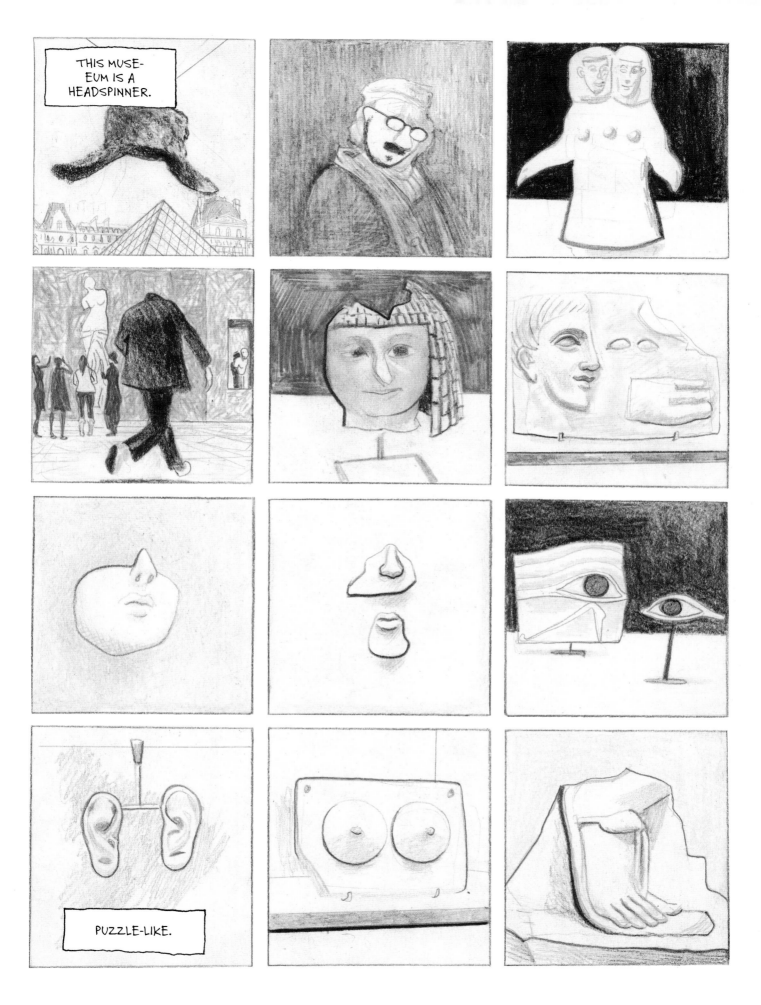

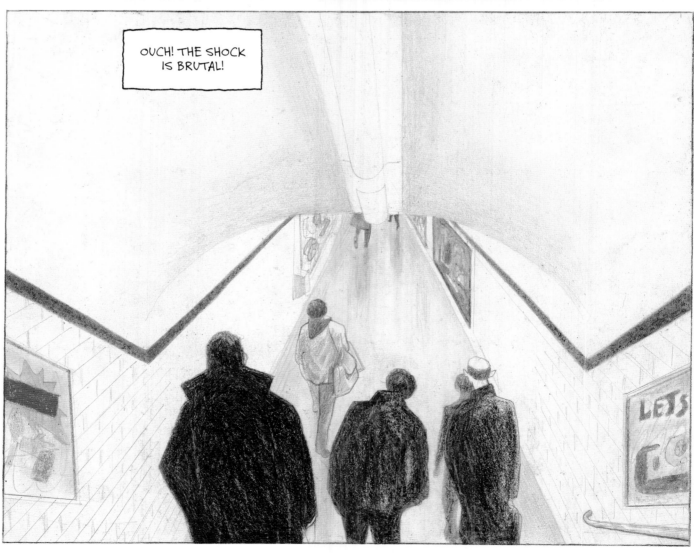

OUCH! THE SHOCK
IS BRUTAL!

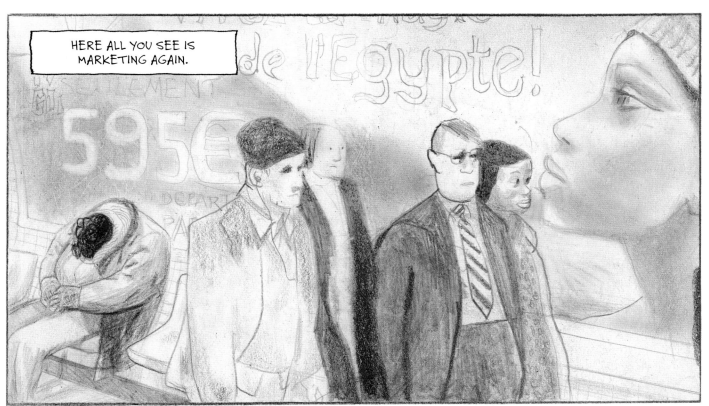

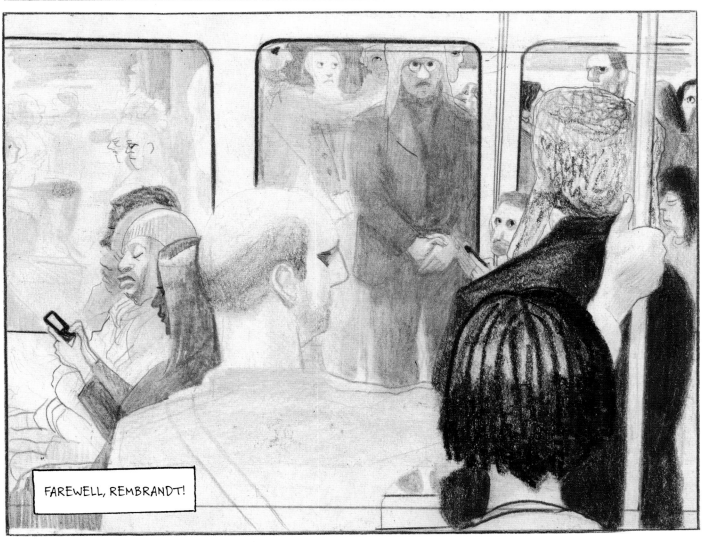

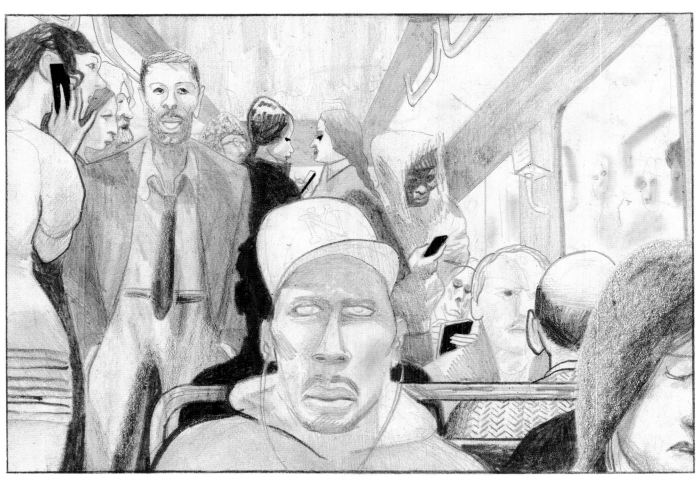

AH! YOU'RE HERE!

OH, I REALIZED PRETTY QUICKLY WE WOULDN'T CROSS PATHS. BUT...

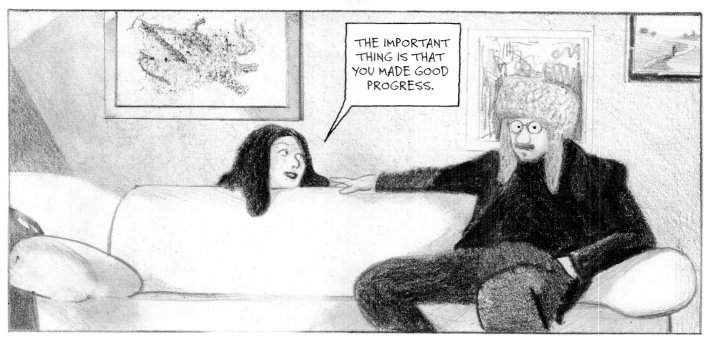

THE IMPORTANT THING IS THAT YOU MADE GOOD PROGRESS.

ANOTHER CRUISE THROUGH **THE LOUVRE...**

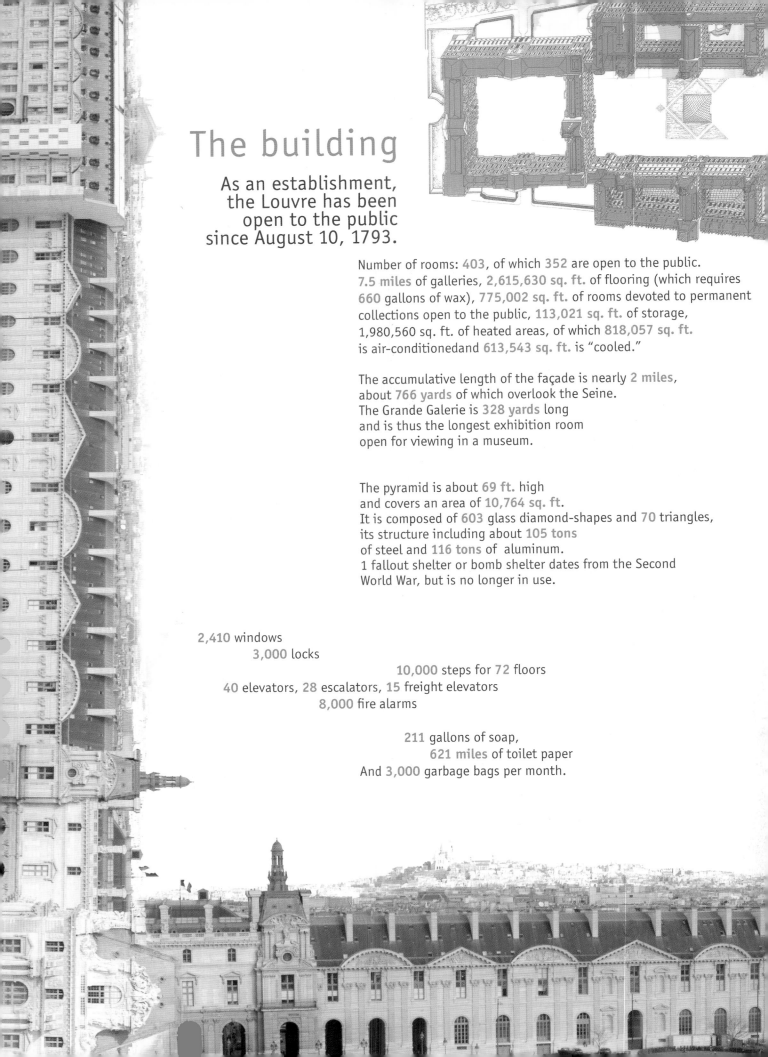

The building

As an establishment, the Louvre has been open to the public since August 10, 1793.

Number of rooms: **403**, of which **352** are open to the public.
7.5 miles of galleries, **2,615,630 sq. ft.** of flooring (which requires
660 gallons of wax), **775,002 sq. ft.** of rooms devoted to permanent
collections open to the public, **113,021 sq. ft.** of storage,
1,980,560 sq. ft. of heated areas, of which **818,057 sq. ft.**
is air-conditionedand **613,543 sq. ft.** is "cooled."

The accumulative length of the façade is nearly **2 miles**,
about **766 yards** of which overlook the Seine.
The Grande Galerie is **328 yards** long
and is thus the longest exhibition room
open for viewing in a museum.

The pyramid is about **69 ft.** high
and covers an area of **10,764 sq. ft.**
It is composed of **603** glass diamond-shapes and **70** triangles,
its structure including about **105 tons**
of steel and **116 tons** of aluminum.
1 fallout shelter or bomb shelter dates from the Second
World War, but is no longer in use.

2,410 windows
3,000 locks

10,000 steps for **72** floors
40 elevators, **28** escalators, **15** freight elevators
8,000 fire alarms

211 gallons of soap,
621 miles of toilet paper
And **3,000** garbage bags per month.

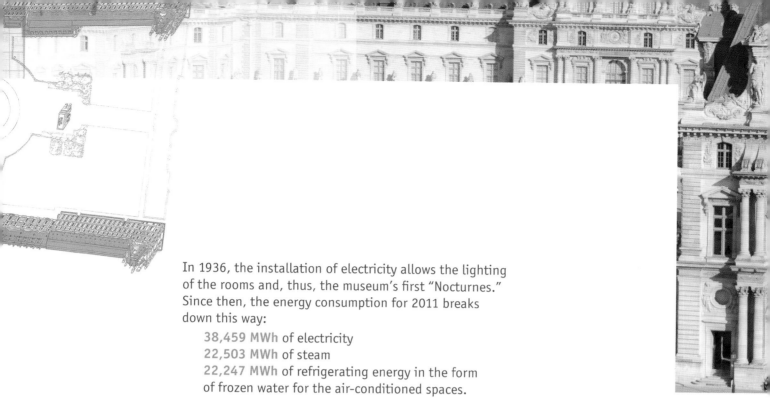

In 1936, the installation of electricity allows the lighting of the rooms and, thus, the museum's first "Nocturnes." Since then, the energy consumption for 2011 breaks down this way:

38,459 MWh of electricity
22,503 MWh of steam
22,247 MWh of refrigerating energy in the form of frozen water for the air-conditioned spaces.

18 High Voltage substations (20,000 volts)
630 electrical cabinets
42,692 exterior lights
52,000 interior lights

On the other hand, it is impossible to estimate the footage of electrical cable, but it must count in the tens, if not hundreds of miles.

But the Louvre is also:

The Laboratoire de Recherches et de Restauration des Musées de France (C2RMF) (Research and Restoration Laboratory for the Museums of France): located on the grounds of the Louvre and equipped with a particle accelerator (Accélérateur Grand Louvre d'Analyse Élémentaire). To this day, AGLAE remains the sole installation of its kind in the world to be located in a museum laboratory. The terminal's maximum voltage of **2 million** volts allows for the production of protons and neutrons possessing an energy up to 4MeV and alphas up to 6MeV.

La Société des Amis du Louvre (The Friends of the Louvre Society) (in existence since 1897):
60,000 members and 800 works acquired for the Louvre.

The École du Louvre:
2,000 students, 15,000 auditors, 25 partner cities and museum in various regions.

The works

Number of works conserved:
Around **400,000** with **35,000** on exhibition.

Department of Egyptian Antiquities: **55,000**
Department of Oriental Antiquities: **120,000**
Department of Greek, Etruscan, and Roman Antiquities: **40,000**
Department of Arts of Islam: **20,000**
Department of Paintings: **7,000**
Department of Sculptures: **7,000**
Department of Objets d'Art: **15,000**
Department of Graphic Arts: **150,000**

Total: approximately **414,000** objects

The largest: The Wedding Feast at Cana by Veronese (approximately **844 sq.** ft.)
The smallest: amulets or pearls (conserved in the Department of Egyptian Antiquities and in the Department of Oriental Antiquities)
The oldest: Statue from Ain Ghazal, Department of Oriental Antiquities (on loan from the Department of Antiquities of Jordan)
The most recent: ceiling by Cy Twombly
The most visited: *The Mona Lisa*

First donor to the Louvre (then Museum): In 1799, **Bertrand Clauzel**, adjutant-general of Napoleon's army of Italy, gives as a gift to the Museum, *The Dropsical Woman* by Gerrit Dou. This painting had been given to him by Charles Emmanuel IV of Savoy (in 1798, at the end of the Italian campaign).

The visitors

Annual number of visitors (in 2011): about **9,000,000**, 67% of whom are foreign visitors and 33% French visitors.

The principal nationalities represented are: **United States** (16%), **Brazil** (7%), **Australia** (7%), **Italy** (6%), **China** (6%), **Spain** (5%), **Germany** (5%), **United Kingdom** (4%), **Russia** (4%), **Japan** (3%), **Mexico** (3%), **Canada** (2%).

Other nationalities represent 32% of the total number of foreign visitors.

Daily number of visitors:
On average, **29,000**
(up to 35,000 and, sometimes, 50,000).

Average tour by a visitor in time and distance: about **3 hours**; on average, **1 mile** visited. If you estimate **10 seconds** spent per exhibited work, you'd need four entire days to see everything, not counting getting around.

Number of photos taken daily: if you start with an average of **12 photos** taken per visitor, you get around **350,000 shots** daily.

500,000 Friends on Facebook
9,000,000 Netizens

In 2011, 6,034 items were registered by the lost-and-found department and 1,548 were returned to their owners. Every two weeks, all unreturned items are turned over to the city of Paris' lost-and-found department (Police Headquarters).

Among the unclaimed objects at cloakrooms and checkrooms, we find knives and blunt objects held at the museum's entrances (Anti-Terrorist Security Alert system), items of little value found on the grounds (books, scarves, gloves, hats, sacks, toys, glasses, etc.), but also high-ticket items (cameras, jewels, cellphones, video cameras, IPads, wallets, and handbags).

The latter items are not solely "forgotten" by their owners, we also find them in pickpockets' hiding places (drop ceilings, elevator machinery, atop windows, statue pedestals, etc.).

The agents

2,200 agents work at the Louvre, to whom can be added independent contractors of all kinds (technical maintenance, CCT surveillance, laboratories, restorers, guest speakers, etc.). Around 1,200 agents are employed in the reception area and as security guards. More than 60 jobs are listed at the Louvre, and a brigade of firemen is permanently stationed there.

Additional information:

Publications: 2,100 laminated flyers in 6 languages (French, German, English, Italian, Japanese, and Spanish) are placed in the rooms to inform visitors. More than 50 works a year (exhibition catalogs, scientific works, children's books, etc.) are published by the museum, as well as a magazine: *the Grande Gallerie*.

Film production: In more than twenty years, the Louvre has coproduced some 170 documentaries on the history of art and the history of the museum.

Filming: Around 480 film shootings can be tallied per year on the grounds of the Louvre and the Tuileries, including 4 or 5 original films (3 feature length ones).

The first film shot in the Louvre was *Belphégar* by Henri Desfontaines in 1927 (in it, in particular, you can see security guards firing pistols in the stairwell of the Winged Victory of Samothrace).

Acknowledgments at the Louvre:

Henri Loyrette, Hervé Barbaret, Claudia Ferrazzi,
Juliette Armand, Serge Leduc, Violaine Bouvet-Lanselle,
Soraya Karkache, Sabine de La Rochefoucauld,
Mariana Duque, Caroline Damay, Catherine Dupont,
Fanny Meurisse, Diane Vernel, Adrien Goetz,
Laurence Castany, Christine Fuzeau, Camille Sourisse,
Juliette Ballif, Martin Kiefer, Xavier Guillot,
Hervé Jarousseau, Chrystel Martin, Virginie Fabre,
Zahia Chettab, Catherine Derosier-Pouchous, Valérie
Coudin, Manon Luquet, Agnès Marconnet, Joëlle Cinq-Fraix,
Ariane Rabenou, Christine Finance, Valérie Buraud,
Maryline Bobant, Sophie Toulza-Colomines, Pierre Besnard,
Jan Sekal, Moïra Parrucci, Alex Crozilhac, Denis Toulmé,
Yves Maisonneuve, Pascal Marchal, Brigitte von Hecke,
Marie Le Maire-Bodnya, Franck David, Charlie Gaget,
Jean-Louis Bellec, Jean-Pierre Clément, Anne Giroux,
Manon Potvin, Bruno Guennou, Ludovic Rozak,
Marcel Perrin, Carol Manzano, Muriel Suir, Clio
Karageorghis, Marie Coste-Genin, Niko Melissano,
Guillaume Thomas, Xavier Milan, Daniel Soulié, Élisabeth
Laurent, Max Dujardin, Irène Juliet and the whole studio
for editing drawings, not to mention all the visitors.

To Nathalie Trafford, Denis Curty, Thierry Masbou,
Christophe Duteil, Emmanuel Hoffman, Cécile Bergon,
Béatrice Hedde, Marc Giner, Carole and Laurence de Vellou
for their invaluable support.

I thank Camille, my darling, who is a character in this story without having asked to be one. She's doing well and still has her head on her shoulders, which is a great help to me in creativity and daily life.

Another person I thank for having his own well-organized mind is "Seb" Gnaedig. Dear editor and friend, your opinions are always enlightening and are precious to me. My apologies for subjecting you, too, to an involuntary contribution by way of the phone call that opens this Louvre ballet. I also made Fabrice Douar—the enthusiastic, kindly editor at the Louvre, who opened wide so many doors in this world-museum and at the restaurant—undergo an imaginary phone conversation.

Thanks to Zahia Chettab. Thanks to Franck David and Charlie Gaget for letting me follow them around the museum during their nightly rounda.
Thanks to Valérie, Maryline and Anne-Sophie for their commentary.
Thanks to Étienne Davodeau, Troubs, Jean-Denis Pendanx, Nicolas Dumontheuil, Lorenzo Mattotti for taking the time to decrypt the sketches and tracks of this story and, through your encouraging observations, contributing to its creation.

This book was drawn, in part, at the house of Professor Demons in Bordeaux and completed at the Novella village in Balagne, Corsica.

The finishing touches, fittingly, are the fruit of the impeccable work of Fabien Phelippot de la Phabe, and Celia Bornas.
Thanks and bravo to Didier Gonord for his visions and ideas. Thanks to Evelyne Colas, thanks to Élise Rouyer, and thanks to Patrice Margotin.
In short, to the entire Futuropolis team, it's a joy to work with you.

David